# fuckwind

poems
and
songs

etruscan books

## etruscan readers

I  Helen Macdonald, Gael Turnbull, Nicholas Johnson

II  Tom Scott, Sorley MacLean, Hamish Henderson

III  Maggie O'Sullivan, David Gascoyne, Barry MacSweeney

IV  Bob Cobbing, Maurice Scully, Carlyle Reedy

V  Tom Raworth, Bill Griffiths, Tom Leonard

VI  Robin Blaser, Barbara Guest, Lee Harwood

VII  Alice Notley, Wendy Mulford, Brian Coffey

VIII  Tina Darragh, Douglas Oliver, Randolph Healy

IX  Fred Beake, Nicholas Moore, Meg Bateman

## etruscan books

*High West Rendezvous* by Edward Dorn

*The Earth Suite* by Carl Rakosi

*Poems* by Seán Rafferty

*The Old Poet's Tale* by Carl Rakosi

*else/here* by John Hall

*A Book of Spilt Cities* by Bill Griffiths

*Shayer's Fish* by Helen Macdonald

*Languedoc Variorum* by Edward Dorn

*Kob Bok* by Bob Cobbing

## exhibition

*Red Shifts* by Maggie O'Sullivan

*5 Freedoms of Movement* by Maurice Scully

*Shrieks and Hisses* by Bob Cobbing

The kistrilles or windfuckers that filling themselves with
winde, fly against the winde evermore.

Thomas Nashe [*Lenten Stuff*, 1599]

# fuck
# wind

# tom
# pickard

*fuckwind* published by <u>etruscan books</u>
24a, Fore Street
BUCKFASTLEIGH
South Devonshire TQ11 0AA

ISBN 1 901538 26 5
First edition of 750 copies

Typeset by R.W. Palmer, at *Tuff Talk Press*, Bath
Designed by R.W. Palmer and Nicholas Johnson

Distributed in USA by
Small Press Distribution, 1341 7th Street, Berkeley, California 94710 USA,
available in England from
Peter Riley (Books), 27 Sturton Street, Cambridge CB1 2QG
and in Australia from
Collected Works, First Floor, Flinders Way Arcade, 238 Flinders Lane, Melbourne 3000

Printed at The Book Factory, 35-37 Queensland Road, London N7 7AN

I was introduced to Tom Pickard by my late friend Allen Ginsberg. Tom helped me sort out *Standing Stone* – a poem I wrote to accompany a piece of my music of the same name. Knowing his reputation for uncompromising language, I am not surprised that the 16th century word for kestrel winged its way into his consciousness. Where else would it fly?

This collection of poems and songs soars over the fells, screeching truth, sex, humour, anger and love. With sharp vision Tom dissects his gut reaction and reminds us to appreciate the cool clear beauty of our own situation.

**Paul McCartney**

## First Set

## Second Set

## Third Set

## Fourth Set

for Svava

*who gave me the space to write the best of the work in this collection.*

# hidden agenda

*manifesto for the leadership of the Labour Party*

I want to be to be an astronaut of fuck
to be flung into orbit around fuck

I want to be the oil in the engine of fuck
turbocharged with the rocket fuel of fuck
I want to spin on the pinnacle of fuck
to absorb fuck through my pores

I want to be swept in fuck
wrapped in fuck
swallowed in fuck
foaming in fuck
free in fuck
fast in fuck
fixed in fuck
loved in fuck

I want accommodation in fuck
security of tenure in fuck
I want to dive in fuck
swim sink and drown in fuck
I want to be re-born in fuck
and die in fuck

I want a daily delivery of fuck
an early morning milk round of fuck
I want to duck diet and dissolve in fuck
I want to dream in fuck

I want to fuck about with fuck
float in fuck shout in fuck

11

dance in fuck
sing in fuck

I want fuck to pour down on me
I want cloud bursts of fuck
and heat-waves of fuck
swamps blizzards tornadoes
and earthquakes of fuck
volcanoes of fuck
floods of fuck
I want to be deluged in fuck
immersed and inundated in fuck

I want flash floods of fuck
waves of fuck
tides of fuck
I want tidal waves of fuck
torrents streams and lakes of fuck
I want to turn on the tap and fill the bath with fuck
I want to be tossed in a force eight gale of fuck

I want fuck falling out of trees
fuck dispensed on the hour every hour
I want to be glutted with buckets of global fuck
inter planetary inter galactic and colliding galaxies of fuck
I want black holes of fuck
forests of fuck
shoals of fuck
showers of fuck

I want cities built on fuck
fermenting fuck
farms of fuck
fields flowering fuck

I want to be lost in the Bermuda triangle of fuck
I want to fling open a window of opportunity and fuck it

I want to be sucked in fuck
tucked in fuck
dipped in fuck
I want to lick fuck
and drip fuck
I want fuck sent to me by special delivery
I want fuck to come by first class post
and fuck for the foreseeable future

I want to be baptised in the font of fuck
to get familiar with the fundamentals of fuck
to become ordained in the order of fuck

I want to travel daily on a fuck bus
to excavate the mines of fuck
to feast in the kitchens of fuck
and be basted on the spit of fuck
to kneel and be knighted by the queen of fuck
*arise Sir Thomas Fuckard and kiss my quim*

I want to live in the welfare state of the republic of fuck
I want fuck on the national curriculum

## waiting for an absence

something has been here before
and everything waits for it to come again

traces remain round sulky bends
velvet peat pissed rocks
built on echoes
shaped by deserting water
insect silent

a scut of earth
cut up and shut up

hills throw themselves at skies
that open and come down
it's very simple
everything waits for it to come again

## twenty first century girl

served my time
in Valentine
break my chains
in love again
get some money
pay her bail
get my woman
out of jail
*my 21<sup>st</sup>    century girl*
*my 21<sup>st</sup> sensory girl*

from Monroe
to Salome
she's so many
I can't keep up
that girl is poison
fill my cup
that girl is poison
let me sup  sup
*my 21<sup>st</sup>    century girl*
*my 21<sup>st</sup> sensory girl*

the second time
you left me girl
the second time
you gave that look
the second time
you gave that look  that look
I wrote a book
about that look
*my 21<sup>st</sup>    century girl*
*my 21<sup>st</sup> sensory girl*

got no ticket
don't care less
baby rides
the love express
where's the money
spent the rent
that girl from hell
was heaven sent
*my 21ˢᵗ    century girl*
*my 21ˢᵗ sensory girl*

## wind rips

a telling wind rips
at the window

your hair on my pillow
we come

as the first thrush sings
spring's in

## this end april

each tree seems to sing
and for the first time
look like summer

skittering sand martins mine holes
in a mud embankment
recently roughed by flood

sitting by the South Tyne
the air spiked with gorse
reading *The Goddodin*

a corbie tilts its beak back
black as your hair
stalks the shallows opposite

## rope

I was writing my book of revisitations
playing a bit part in a melodrama
the angels walked out of

when Michael de Freitas, aka
Abdul Malik,  aka Michael X,
(executed Trinidad 1973)
knocked on my door.

*Is Tom Pickard here?*
*No,* I said, *but when I see him*
*I'll say you called.*

Was my rent overdue?
Who would hire the dead, who
require no wages, work all hours,
and for whom conditions
could never be bad enough?

I'll never know what he wanted,
that man with hell knotted at his neck
till I meet him there.

A grudging dawn
and the grass is grey.

Let there be day when I die
at least a gob of red in the east.

They say there is a light
brighter than the biggest arc
in the dullest prison yard
when rope draws tight
to snap the switch
from this to that.

**cunt**

another dead man
another dream
I told him after lunch
I'm going to write
a poem about the cunt

lip stiff elastic
electricity
     of tongue skipped
     mid air
hair
   sounded
     on a mound
palm rounded

     fibrillating corolla
       sea scented
     tide foam
damp straw
     fresh   cut hay
chaffinch in a dark
  spring wood
  hooded crow

afterfuck engorged
clough chuffed
  moon chilled cheeks
     speak

no metaphor
          or spent pics
when tongue flicks
      trick laughter
after
ripples
          over river rocks

lounging on my sofa
          looking up *labia*
in the OED
you in an ironic blue shirt
bring me
          *'Aristotle's Masterpiece'*
and lie down
          by the fire

but when I joked
Poseidon personification
of the clitoris
  you took the hump
because I misgendered
          the cunt

then I dreamt
you gave birth
          in our bath
  to a girl
who spoke
as the surface
  of the water
broke

## Valéry in the gallery

I saw Valéry in the gallery
with his boy friend Rabelais
he was wearing Braque pyjamas
and a Matisse negligee
Dostievesky put a bet on
at the booky's down the road
Picasso was a jockey riding on a toad
Lorca got his throat cut
carried such a load

Elvis playing sheriff
while Oscar's standing trial
Martin Luther nailed his Mutter
to a church door called denial
The Marquise de Sade was very very bad
he was sad sad sad
I asked Marcel Marceau
he ought to know
Marcel Marceau

I saw Valéry in the gallery
with his boy friend Rabelais
he was wearing Braque pyjamas
and a Matisse negligee
Dostievesky put a bet on
at the booky's down the road
Picasso was a jockey riding on a toad
Lorca got his throat cut
carried such a load

Damian drew a hearse
and he put it on display
Kerouac bottled Jack
and he couldn't get away
Howling Wolf rode Virginia
through the waves
Sitting Bull thought the White House
was a lighthouse
for his braves

I saw Valéry in the gallery
with his boy friend Rabelais
he was wearing Braque pyjamas
and a Matisse negligee
Dostievesky put a bet on
at the booky's down the road
Picasso was a jockey riding on a toad
Lorca got his throat cut
carried such a load

## gypsy lady

saw the gypsy lady
told me all bad news
said I'm going on a journey
to the land of the blues

saw the gypsy lady
said cross my palm with blood
I'll tell you bout your future
an it don't look good

took me to the station
took me by the hand
said her destination
was with another man

saw her in the dockyard
showed me the slip
says she's gotta cruise
the relationship

saw the gypsy lady
dancing in my cups
spread her legs dealt her hand
hung me hanging up

saw the gyspy lady
said cross my palm with blood
I'll tell you bout your future
an it don't look good

## day drugged

I was delirious
day drugged
sky-highed
river ripped
tree tripped
cloud cut
stone stoned
pine-spliffed
skint as a skinned rabbit

I was sprig jigged
merlin skirted
pool cooled
bark charged
wind blown
grass gassed
thorn horned
bud rubbed
hawk hung
skint as a skinned rabbit

I was bat ratted
viper wiped
adder blasted
hope toked
stoat soaked
bush lushed
hop crushed
soil oiled
bee sotted
skint as a skinned rabbit

I was syke spiked
curlew crashed
moss coshed
heather happy
badger blasted
storm tossed
tit tipsy
linnet lathered
peewit potted
skint as a skinned rabbit

I was wall wasted
dipper dippy
mushroom muddled
meadow muzzy
sorrel sozzled
fanny fuddled
womb woozy
minge merry
quim skimmed
skint as a skinned rabbit

## first of may

*for Ed Dorn*

the sky is full of flying fannies
you sit on my face
I eat an apple from your cunt
you laugh
my mouth full of cloud
your hair
dark
as the day before dawn
may-day today
may-day

## may

may
in her black hair
a bridal charm

she blows a lacewing
from her arm

dark hares
white through blue

a blackcock flew
across
a flowering ash

she sucks
my cock by rock
cinquefoil

a comma settles
on her thigh

windfuck
fucks wind

raving waters
rush
the clough

overhung
with campion

stitched
with thyme

**blue**

that was a beautiful blue
you wore tonight
it clung to you
and hung just right

I turned away
what I meant to say
how love you looked today

marvellous in moonlight
and in your dawning
marvellous in morning

## pencil

take this
to awake

and snake
unsprung

thought
with grace

let this common tool
fine tune custom

make such
a part of hand

awareness
is
a digital audit

I once dreamt
a pen wrote

illuminated ink
like neon

may your words
glow a river rush
after rain

sometimes
think of me
when you hold it

## skint

I wanted to buy you
a dark amaryllis
deep as a well
of blood

I could not question
although
I understood

but I was skint
and wrote this instead

## www.warm.wet.woman

got a message on my e-mail
and this is what it said
I'm a warm wet woman
on the world wide web
I'm a warm wet woman
on the world wide web

love is all
love is all
love is all
love is all out war
there are no prisoners
not any more
love is all out
all out war

she's a butterfly dancing
in a chrysalis
she's a butterfly dancing
on a clitoris
she can't wait to get out
I can't wait to get into it

sent a message on my email
this is what it said
landlord thinks ahm running
money thinks ahm dead
dancing in the dole queue
bullet in the head

love is all
love is all
love is all
love is all out war
got no e
got no e
got no e
dentity
only a poor
man is free
he got no
e
dentity

love is all out
love is all out
love is all out war
there are no prisoners
not any more
love is all out
all out war

she's a warm wet woman
on a world wide web
got a message on my e-mail
that's what it said
I'm a warm wet woman
in a world wide web

## interactive poet

he's an interactive poet
to a girl he's never met
but they're going steady
going steady on the Internet

she connects to Canon Luce
playing Whip My Neighbour
father was a Tory
but he always voted Labour

going steady going steady
going steady on the Internet

she slips into her Internet stockings
jacks a fax
into her modem
she's got all Friday night
and the rest of the world
to stroll in

dyke snakes local bike
done with sneaking and cheating
she feels like Lauren Bacall
but she looks like Buster Keaton

going steady going steady
going steady on the Internet

be wise get smart
cold arse warm tart

## to meet my lover again

footsteps in the street
turned my head
and heard
my heart beat

I raise my foot
to lift the gate
that I pass through
when I go to
meet my lover again

the wind is like her breath
hot in my ear
cool on my neck

a tight clough heathered thighs
where we lie
whether wet or dry

night walks
the streets below
wearing a dark suit
stitched with starlight

the milky way a spider's web
lying on my empty bed
till I meet
my lover again

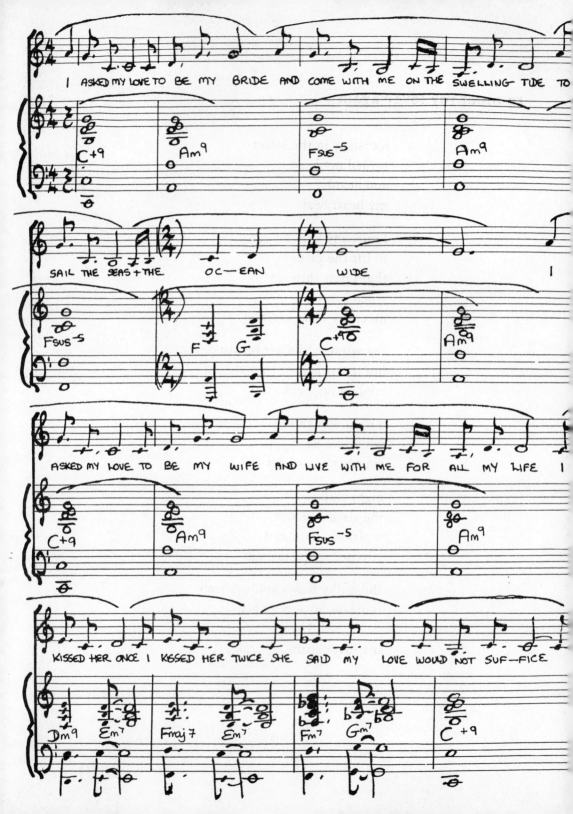

## the ballad of Jamie Allen

I asked my love to be my bride
and come with me on the swelling tide
to sail the seas and the oceans wide
away boys away

I asked my love to be my wife
and live with me for all my life
I kissed her once I kissed her twice
she said my love would not suffice

I thought my love my love would bless
when I brought my love a crimson dress
but the crimson dress did not impress
my love she laid my love to rest

she said she would not be my bride
so I stole her away on the red'ning tide
and sailed her out to the ocean wide
away boys away

## dark

dark cloud
over Howly Winter

the wind persuades
a tree to talk

and what it says
is

## holymire

a slit
of early moon

the orb of her dark eye
lined with thin silver

hawk hesitation
in a hung out sky

**rift**

she plucks a feather
from a swift in flight
as I lift her slip and sink
to inhale the pinks at her hip

her buttocks are dusted
with afternoon sunlight
and the hillside shakes
a snaking river

**wroth**

fast syke
lap-dogging rock

a roe deer's ears
hover
overhead

a buzzard hung
swung
above the thinning
thicket

ballet swank
of a salmon
a sudden

fuck in the storm

## not just place

echo
of a dried up clough
grey cumulus
bellies on the fell
two narrow
bracken tracks
conflux

snatch of violets
on a bank of thyme

amassed patch
black cloud
scats
the horizon

the sun hung
under
out of sight

do it easier
coming back
the hard way

## Satchi & Satchi

*(Archie & Sparky)*

Hatch it & Thatch it
Thatch it & Sack it
Sack it & Sack it
Sack it & Knack it
Knack it & Wrack it
Wrack it & Stack it
Stack it & Cap it
Cap it & Strip it
Strip it & Rip it
Rip it & Cut it
Cut it & Gut it
Gut it & Fuck it
Fuck it & Shut it
Shut it & Shaft it
Shaft it & Cash it
Cash it & Cash it
Cash it & Slash it
Slash it & Scrap it
Scrap it & Rape it
Rape it & Rape it
Rape it & Scrape it
Scrape it & Shake it
Shake it & Shake it
Shake it & Break it
Break it & Snake it
Snake it & Snake it
Snake it & Fake it
Fake it & Take it
Take it & Take it

Rot it & Fly it
Fly it & Crash it

Crash it & Stash it
Stash it & Stash it
Stash it & Track it
Track it & Rail it
Rail it & Sale it
Sale it & Ship it
Ship it & Slip it
Slip it & Slip it
Slip it & Stick it
Stick it & Stick it
Stick it & Sick it
Sick it & Lick it
Lick it & Lick it
Lick it & Drip it
Drip it & Drip it
Dripit & Drill it
Drill it & Kill it
Kill it & Kill it
Kill it & Spill it
Spill it & Spit it
Spit it & Shit it
Shit it & Shit it
Shit it & Frame it
Frame it & Claim it
Claim it & Name it
Name it & Name it
Name it & Catchy
Catchy & Snatchy
Snatchy & Snatchy
Snatchy & Scatzy
Scatzy & Scatzy
Scatzy & Scratchy
Scratchy & Scratchy
Scratchy & Satchy
Satchie & Satchie

**bulimia oblivia**

I
[*h*]ate
it

too many too often too soon
and never enough
when you need them

## landscape

landscape
your face

unfolding
space

pea
cock

## making of a Gothic moment

recovering from a late night drunk
an uneasy unspecified remorse

at the kitchen table you write an essay
on *landscape in Gothic literature*

a siskin at the window sings
the assonance of assertion

before taking up a book I look to the law
and remember you, at this view, naked

your fingers clatter on a laptop
a chaffinch repeats and repeats and repeats its repetitions

I want to abandon my face in your thighs

a forbidding uncontrollable terrain
tumultuous, tenacious and sublime

## working girl

flopped out on a loppy sofa
from working the bar
you sleep on my shoulder

the street runs up
beneath the window
where plane trees pale
in cloud

a pair of bullfinch strip
in flowering current
thrilled spring's spilt
their wings the colour

of mountain mist
blist in sunlight

**tynehead**

fucking on the top fell
at the river source

the oozing blush
of your cunt

## late summer loot

foraging fungi
  among oak
and birch along
a railway track
slippery-jack
 kisses under
Scots fir
  she squats
a prick
early brambles
  pink
her fingers
  pluck
chanterelle
a surge of wind
  quicks pine
needles

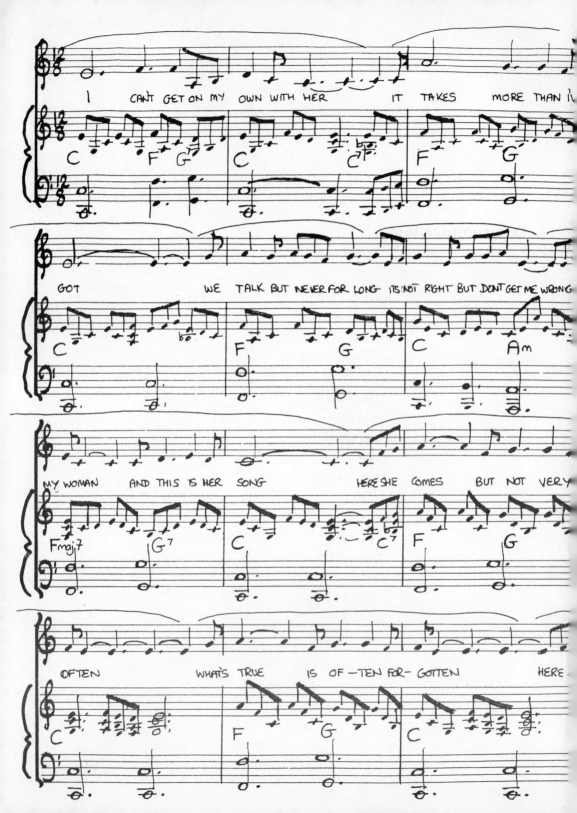

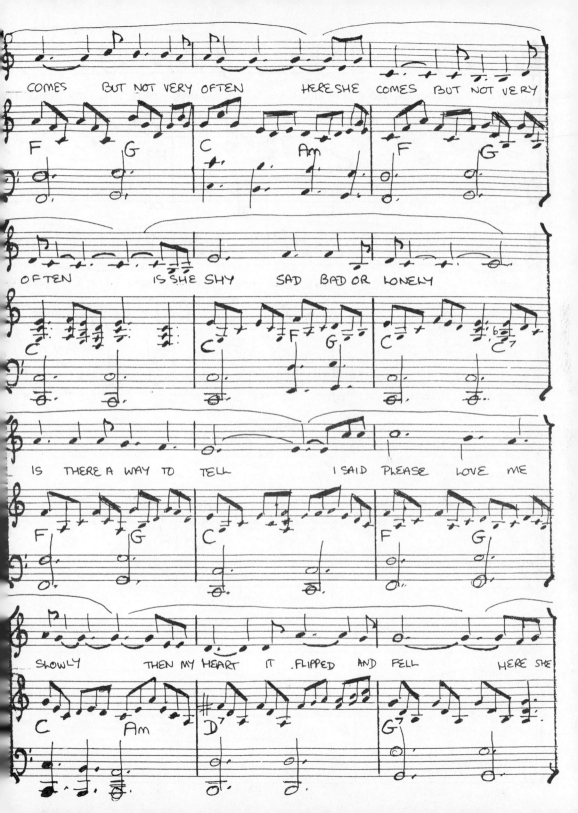

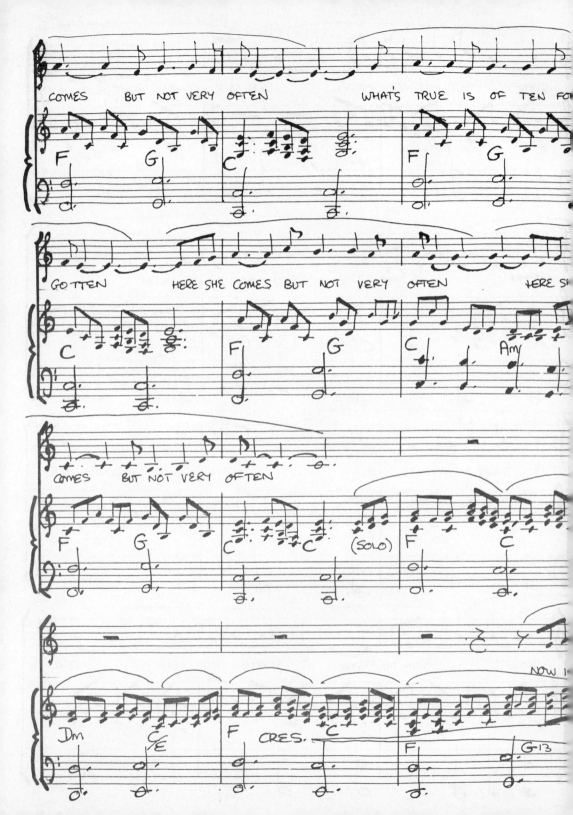

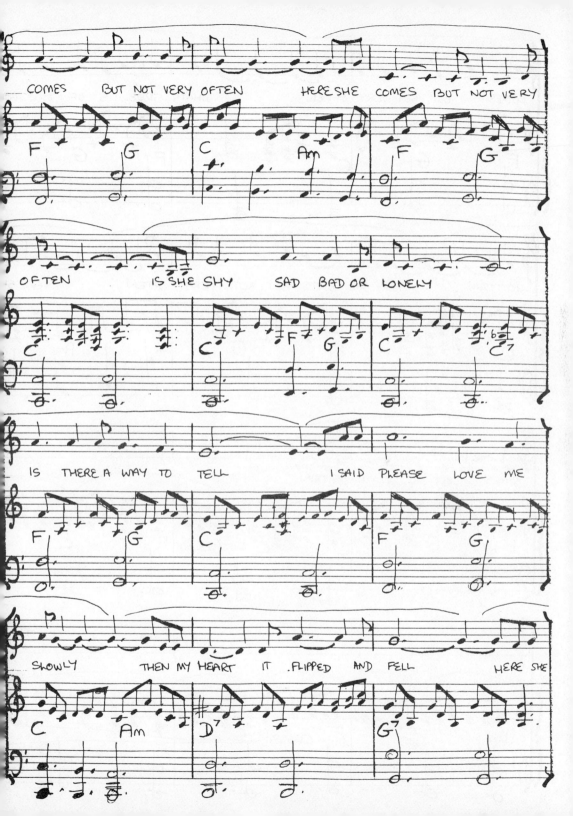

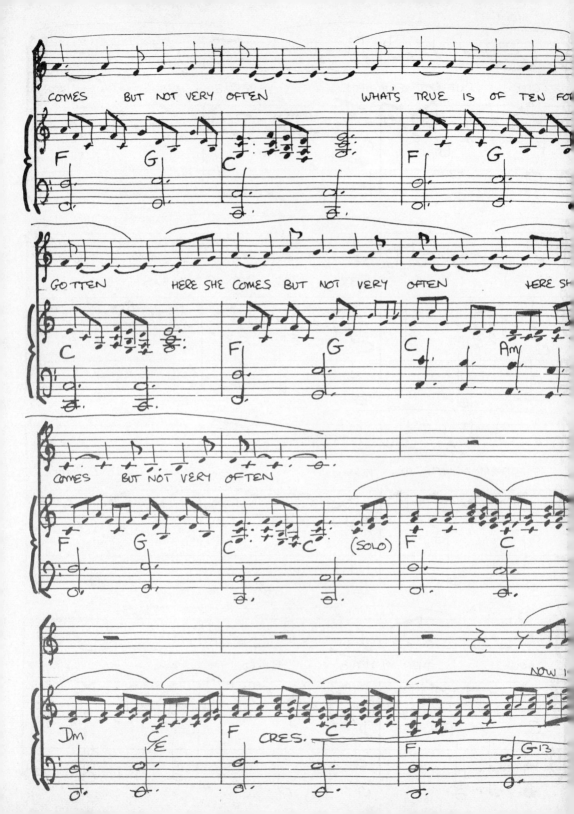

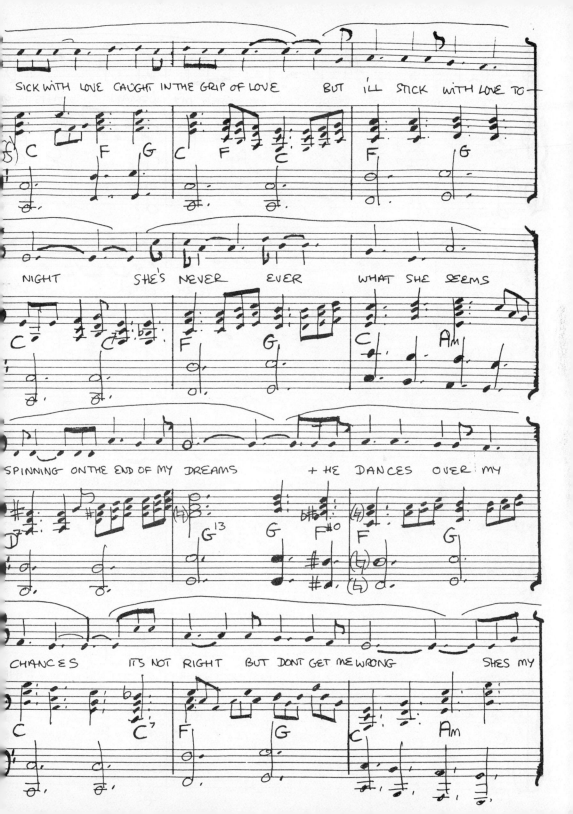

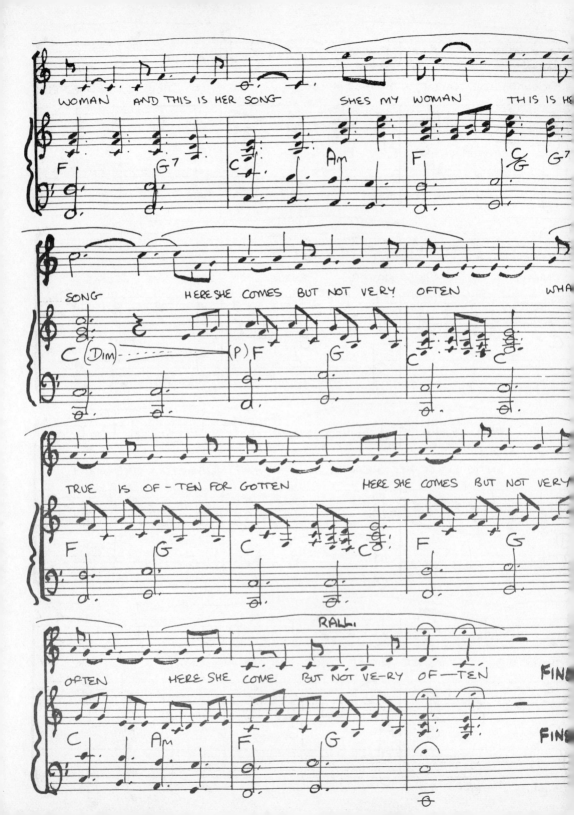

## stick with love

I can't get on my own with her
it takes more than I've got
we talk, never for long
its not right but don't get me wrong
I'm her man and this is her song
What's true is often forgotten
here she comes
but not very often

Is she shy, is she sad,
bad or lonely?
Is there a way to tell?
I said love me slowly
then my heart flipped and fell.
Here she comes
but not very often
What's true is often forgotten
Here she comes
but not very often

Now I'm sick with love, in the grip of love
but I'll stick with love tonight.
She's never ever what she seems
spinning on the end of my dreams.
She dances all over my chances.
Its not right but don't get me wrong
I'm her man and this is her song.

Here she comes
but not very often
What's true is often forgotten
Here she comes
but not very often

**birds & bees**

lowpin lanky grass
with a softlob like
a dippa hittin watta

                                                 three bees
                                                  shuffling shoulders
                                               muff-scrum
                                                       a thistle

goldfinch

a warbling juggler
gargling marbles

## ramshackled hacker

He's a ramshackled hacker way back from beyond
he's a ramshackled hacker way back from beyond
in a nanosecond baby, he's gonna abscond

*Don't want to miss his miss*
*Don't want to miss his miss*
*Don't want to miss his miss*
*in cyber-bliss*

He's a cosmic cowboy at universe city
He's a cosmic cowboy at universe city
He's got a doctorate in escape velocity

*Don't want to miss his miss*
*Don't want to miss his miss*
*Don't want to miss his miss*
*in cyber-bliss*

Slip his bail and list him missing
Slip his bail and list him missing
tell the bounty hunter he gone cyber-fishing

He's a ramshackled hacker way back from beyond
He's a ramshackled hacker way back from beyond
in a nanosecond baby, he gonna abscond

*Don't want to miss his miss*
*Don't want to miss his miss*
*Don't want to miss his miss*
*in cyber-bliss*

## save the shark

have you seen my limousine
its green
you can lick it clean
make it gleam
in the dark
save the shark
turn out the light
see in the dark
save the  shark

saw your mother
in between
the sheets
of a magazine
you can see her
in the dark
where she shows me
how to park
see it spark
turn out the light
see in the dark
feed the shark

took off my suit
put on my tie
as she lay me down to lie
she don't even
have to try
to

turn out the light
see in the dark
turn out the light
and save the shark

hold the flight
what's the rush
saw a bird hung
in a bush
another dawn don't mean much
who's around that you can trust
to
turn out the light
see in the dark
turn out the light
and feed  the shark

your face is where
its always been
stuck up on a
tv screen
shaking hands
with the queen
she don't tell you
where it's been
like a pig in a pork machine
heard it scream
turn out the light
see in the dark
turn out the light
and save
the  shark

peel my grapes before they're plucked
my tuxedo neatly tucked
lying face down in the dust
my accountant says I must
sell my body to the trust
I don't want to but I'm bust
turn out the light
see in the dark
turn out the light
and feed
the
shark

## blackberries at dusk

a thermal flipped
buzzard shits
sun snatched
and streaked
against

a naked sky

bridesmaid blossom
tears
a veil that
spiderwebs and trails
the pricking patch

thorns
write runes
on my wrist

I stretch
and twist to reach
a cluster
opium black

blood bubbles that
suck in light
invite

plunder

night nipples
laced with foliage
fall
into my
palm cup
with

just a touch
or tug
from beak of

finger
and
thumb

the river after
rain between

wind sweeps that voice

a beech with
waves
of breaking sea

and some fuck dunnock flits
a storm ripped leaf
from tree to gorse

gathering
in the dark

squirting out
its song

**starlings**

flyting street
   of  twisting sheen
starling
   your glittering sing
your pharaoh's wing

gift of kin
common flock
star net
 make light spin

speckle neck
laced
with star flecks

star splat
   in Starlingstraat

conspiraling flame flock
 glutton cock
little old ladies
in lurex

skimmed silk
 precision preen
shiver green
blue
      in your black

city shifter
witness to wars

sun shiner
   light miner
quilt of sparks
tarmac
      with oil spills

alight
diffused
   in flight

## kip law

a hot September day
lying naked on wet grass
your nipples
squeezed with wild
lemon-thyme

a buzzard
in a circling sky
wings over
your shoulders

## absolute

sunlight after sex
first frost on the fells

a crystal apron dissolves
in a lap of certain light

water in a bedroom cup
cold clear

and the air sure

## dawn self sacrificial

blister of burst light
across a wind plucked brow
of undressed trees

a knuckle
of sun punched cloud
bruised red at the edges

but when you walked
her home
with comforting talk
of *him* punishing *her*
did you leave
a sticky kiss
a lick
too long
on her quivering lips
a reminder of what
and where
joy is

if I had a heart
you'd take it

here
stake it

in an Aztec grave

that's what slaves
are for

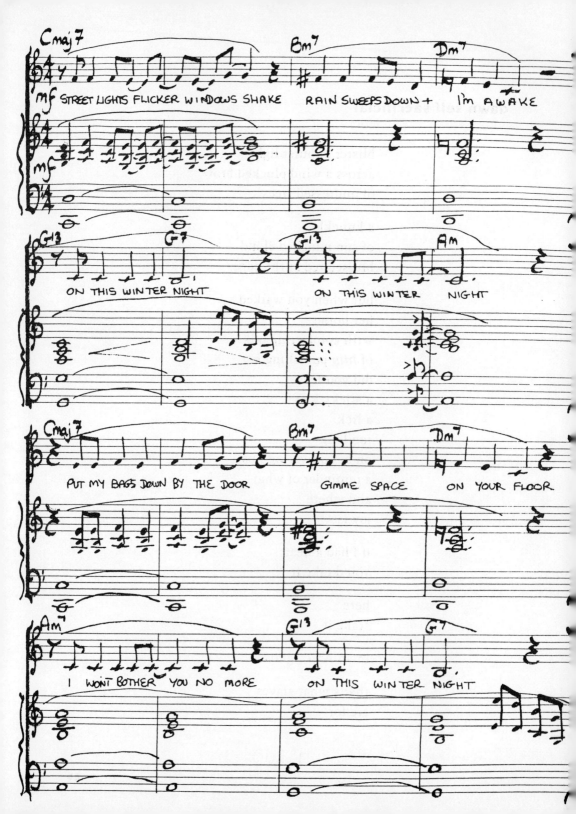

## winter night

street lights flicker windows shake
rain sweeps down and I'm awake
on this winter night
put my bags down by the door
I won't bother you for more
streets outside are long and cold
I am getting far too old
I don't need to be told
on this winter night

call a priest call the pope
gimme shelter gimme hope
gimme some more fucking dope
sell my body for a bar of soap
on this winter night
ride the buses all night long
listen to a busker's song
he won't be singing it for long
on this winter night

fuck the beggers fuck the poor
we don't need them anymore
gimme shelter let me score
on this winter night
let me drink lord let me sleep
I might be poor but I'm not cheap
gimme snort gimme crack
gimme smack lord by the sack
till it breaks my fucking back
on this winter night

street lights flicker windows shake
I don't want to stay awake
wind and rain and howling storm
bless the day that I was born
bottle breaking bloody dawn
another winter night

## frosted

frosted lace
of a kicked up
petticoat
a wedding dress
is cold—but bright
strutting wings and
fan flicked tail
a moody blackbird
pruning on a lop
of hawthorn
chucks a black cat
casually seeking
camouflage
in snow

two starlings dart
towards a tree
score
double top
below a circle
school girls
kicking footballs

how is it
when we kiss
you taste
water
licking down
moss coated
cloughs

a shower of starlings
storm past

meteorites
are predicted
tonight

where fur
is fabric
the skin of my hand
leathers

## when I no longer see you

when I no longer see you
may those who see you see you well
walking with a long view
by some swelling water or declining fell,
wearing, as you do now, a sleeveless blouse
your girlish shoulders, straight back
once dark hair thinned and silvered,
as the sky your bold eye scans

someday by a confluence of buried river
and submerged stream
not beached I hope nor lonely
remember days adrift in cloud
the scented meadows of our flesh:
while walking city streets or wooded track
when bones compound or twist your spine
let those who see you see you well

## when one lover dies

wind machine
behind black
winter trees
spins a rainbow
on a curtain
of cloud

when one lover dies
the world betrays us
morning come
night embrace us

when one lover dies

## widow's mite

bag of trouser snot
slow rolling sky
the colour of cold fat

no dignity in rags but
the bodies that wear them

always the poor who feed the hungry
always the hungry who feed the starving
always the starving

## grave song

slow light
   lifts
low clouds
   your legs
on the bed
   spread
skin
   silk liquid
  mist
finger
    your clitoris
swelling
   breath

your
dawning
   marvellous
in morning

Twenty-six copies of *fuckwind* are lettered A – Z by the author and contain an additional hand written poem. A further 74 copies are signed and numbered 27–100 by the author.

## OTHER BOOKS BY TOM PICKARD

| | |
|---|---|
| *High on the Walls* | Fulcrum Press, 1969 |
| *The Order of Chance* | Fulcrum Press, 1971 |
| *Dancing Under Fire* | Middle Earth Books, 1973 |
| *Hero Dust  New and selected poems* | Allison and Busby, 1979 |
| *Ok Tree* | Pig Press, 1980 |
| *Custom and Exile* | Allison and Busby, 1985 |
| *Tiepin Eros  New and selected poems* | Bloodaxe Books, 1994 |

Prose works:

| | |
|---|---|
| *Guttersnipe* | City Lights, 1971 |
| *Jarrow March* | Allison and Busby, 1981 |
| *We Make Ships* | Secker and Warburg, 1989 |

# ACKNOWLEDGEMENTS

I would like to thank the editors of the following journals where some of these poems were first published: *Chicago Review, Poetry Scotland, Sniper Logic, New Statesman & Society*, and the *David Jones Journal*. And to Tom and Val Raworth, (*infolio*), for publishing 'hidden agenda' with my grouse at its temporary banning in the *New Statesman & Society* who, having commissioned it, thought it unseemly in the company of pieces by or about Tony Blair and upright trade union leaders.

'when one lover dies' was first published on a postcard with a photograph by Linda McCartney on the occasion of a reading at her exhibition in America: *Linda McCartney's Sixties*.

Thanks to Graham Smith for the picture and the time he took.

Photograph on back cover by Angus McDonald: Graffiti on the streets of Newcastle upon Tyne, October 1969, after Tom Pickard was arrested during a performance and banned from the first (and all successive) Newcastle Festivals.

I would also like to thank Liane Carroll and Peter Kirtley for the all too brief times we were able to work together, and for the great pleasure the collaboration gave me. A partial fruit of that collaboration may be heard in a song on **Peter Kirtley: Bush Telegraph** (Plan CD13), and on **Dolly Bird: Liane Carroll Live at Ronnie Scott's** (JHCD051).

Five of these songs were recorded at Paul McCartney's studio *Hog Hill Mill* and my thanks to him for that. Thanks to his engineers, Eddie Kline and Keith Smith and also to Geoff Emerick for his guiding ear.

Anyone wishing to be informed when a CD of the songs is released should send a s.a.e. or email address c/o etruscan books.

Thanks to Liane Carroll for notating a few of the songs in this volume, and to Nicholas Johnson for his enthusiasm and energy.